ROAD TRIP!

COLORING BOOK

Color Your Way to National Parks, Landmarks, and Roadside Attractions

illustrated by LEA CAREY

Clarkson Potter/Publishers
New York, New York

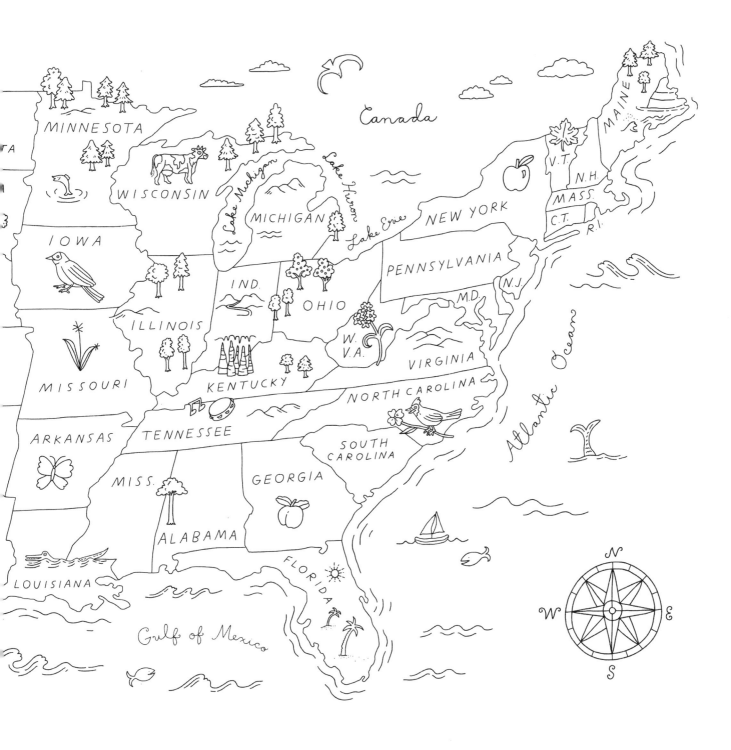

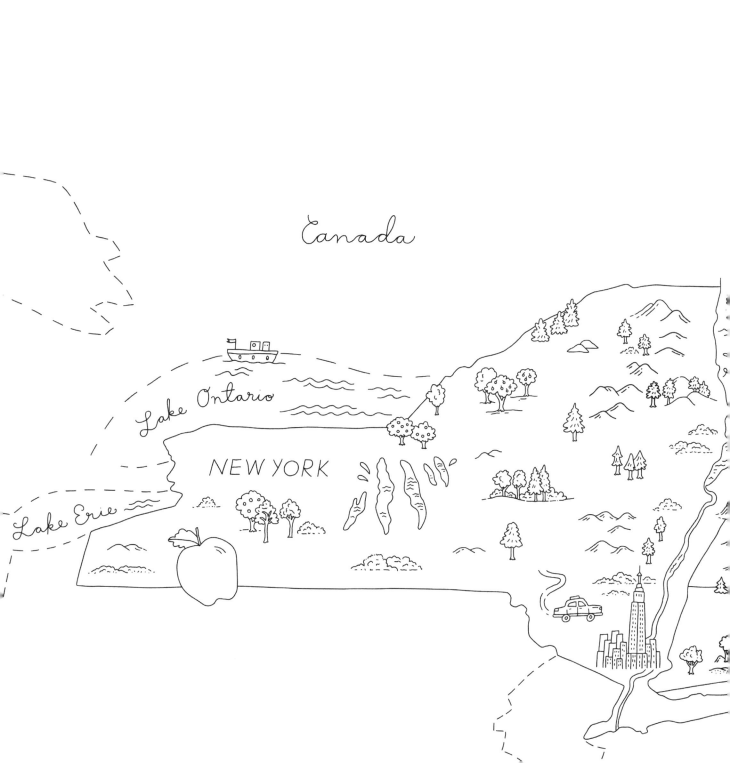

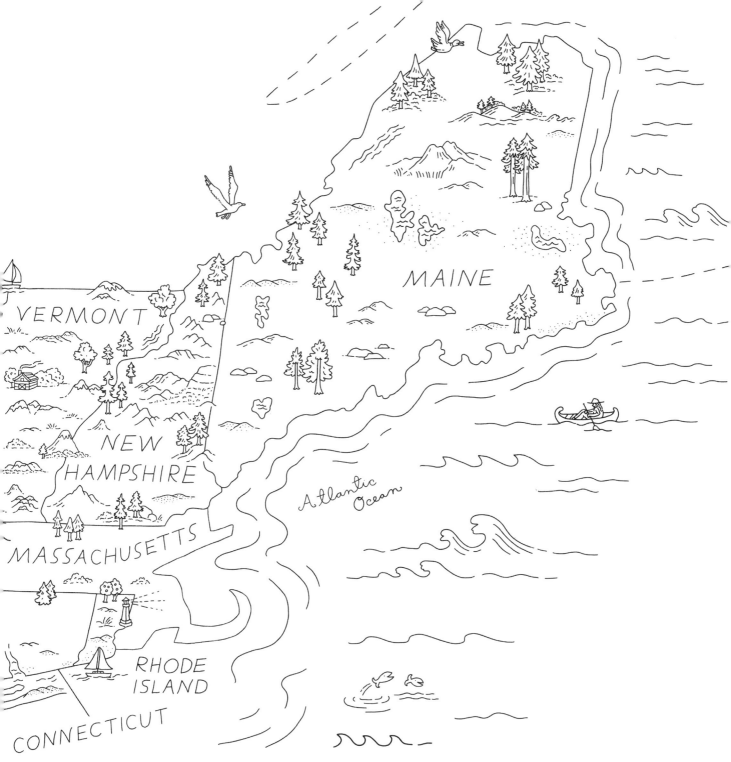

Established in 1919, Acadia National Park protects the highest rocky headlands along the Atlantic coastline of the United States, a wealth of wildlife, and a rich multicultural history. Acadia was the first national park designated east of the Mississippi River. The park resides on Wabanaki land, home to the Maliseet, Micmac, Passamaquoddy, and Penobscot tribes. It is also home to a legacy of scientific research focused on geology and climate change. With more than 150 miles of hiking trails, stunning seaside views, and old carriage roads from the Gilded Age, Acadia has secured a spot as one of the top ten most visited national parks in the country.

ACADIA NATIONAL PARK

MOUNT DESERT ISLAND

MAINE

TOP EXPERIENCES

 1

Bird-watch at the **Nesting Cliff**. Keep your eyes peeled for the recovering endangered peregrine falcon, a beautiful bird of prey, well known for its swift, sharp hunting abilities and grace.

 2

Tide pooling! Sea snails, crabs, anemones, barnacles, and sea stars are abundant in the park's tide pools. Check out **Wonderland**, **Ship Harbor**, and the **Bar Island Land Bridge** to catch a glimpse of Acadia's robust marine life.

3

Cadillac Mountain is the highest point along the North American seaboard. Drive up Cadillac Summit Road or hike one of the steep trails forged at the turn of the twentieth century to see the breathtaking views.

With more than four hundred miles of stunning coastline and a range of state beaches, sheltered coves, and cliff-side views, Rhode Island lives up to its nickname, the Ocean State. The state is home to dozens of beautiful beaches that are often overlooked in favor of their high-profile neighbors, Cape Cod and the Hamptons. Nature lovers spot wildlife at Napatree Point Beach, within the borders of the Napatree Point Conservation Area; hikers trek up the rugged Mohegan Bluffs on Block Island to capture dizzying views of the ocean; and Narragansett Town Beach is a surfer's delight. With a little digging, visitors are sure to find a Rhode Island beach that suits their needs.

THE BEACHES OF RHODE ISLAND

BLOCK ISLAND, NARRAGANSETT,

WESTERLY, AND MORE

RHODE ISLAND

TOP EXPERIENCES

(1) Stroll along the famous **Newport Cliff Walk**, a three-and-a-half-mile-long path set along the coast behind a string of magnificent Gilded Age mansions, before visiting the **Save the Bay Exploration Center and Aquarium** just east of downtown Newport.

(2) Visit **Rail Explorers** in Portsmouth for tours along the historic Newport and Narragansett Bay Railroad and get a view of the **Green Animals Topiary Garden**, the oldest of its kind in the country!

3 Climb the steps of **Southeast Light**, one of two lighthouses on Block Island, a national historic landmark whose grounds offer stunning views of the Atlantic.

Vermont, coming from the French words *vert* (green) and *mont* (mountain), was christened by the French explorer Samuel de Champlain, who named the state for its lush, verdant mountain ranges. In addition to its famous alpine terrain, Vermont is home to a robust dairy industry, which accounts for most of the state's farming economy. Dairy businesses have seen a steep decline since 2000, however, with overdevelopment squeezing farmers off their land. The Vermont Sustainable Jobs Fund, along with the Vermont legislature, created the Farm to Plate Investment Program to aid and strengthen Vermont's food and farm sector, improve soil, water, and resiliency of the working landscape, and improve access to healthy food for all Vermonters.

VERMONT FARMS AND LOCAL FOOD SCENE

BURLINGTON, BRATTLEBORO,

AND SOUTH BURLINGTON

VERMONT

TOP EXPERIENCES

1. Maple syrup is one of Vermont's most famous commodities. Visit a **sugarhouse** during peak maple season (from March to mid-April) to see how it's made!

2. The **Brattleboro Farmers' Market** is a paragon of Vermont's localized, sustainable food ethos, featuring dozens of new vendors each season who sell their wares from May through October.

3. Farm-to-table dining is embedded in Vermonter culture. Check out the restaurant scene in big cities like **Burlington**, **Brattleboro**, and **South Burlington**.

The Blackstone River Valley is often labeled the birthplace of the Industrial Revolution. For centuries, the Narragansett, Nipmuc, and Wampanoag people supported life in the valley with a substantial network of river crossings and game routes for trade and communication. In the late eighteenth century, the English industrialist Samuel Slater constructed a cotton-spinning mill along the Blackstone River, and the region's textile industry blossomed. By the mid-nineteenth century, the river and its tributaries powered more than one hundred mills and mill villages. As business boomed, English settlers used the trade routes established by the Indigenous people of the region to revolutionize commercial transportation in the valley and beyond.

BLACKSTONE RIVER VALLEY

NATIONAL HISTORICAL PARK

RHODE ISLAND AND

MASSACHUSETTS

TOP EXPERIENCES

 1

Visit **Old Slater Mill** and the **Kelly House Museum of Transportation** to learn more about the region's industrial heritage.

 2

Traverse the **Blackstone River Bikeway**, a stretch of forty-eight miles between Worcester, Massachusetts, and Providence, Rhode Island.

 3

Paddle along America's "hardest-working river" to view urban landscapes, historic villages, farmlands, and forests in the national historical park.

Along New York State Route 24, passersby may catch a glimpse of an oddity reserved only for kitschy American roadside attractions. The Big Duck resides in Flanders, New York, overlooking Reeves Bay on Long Island. The thirty-foot-tall building was originally constructed in the neighboring town of Riverhead, where duck farmer Martin Maurer hoped to capture consumers' attention and generate support for his farming business. Maurer enlisted the Broadway set designers the Collins brothers to design the structure, and local builders completed the vision. The shop closed in 1984, and the building was relocated from Riverhead to Flanders. The Big Duck is now listed on the National Register of Historic Places.

THE BIG DUCK

FLANDERS

NEW YORK

TOP EXPERIENCES

Just three miles away in Riverhead is the **Long Island Aquarium**, an interactive educational site emphasizing the importance of marine life and environmental preservation.

②

The Railroad Museum of Long Island in Riverhead is a museum dedicated to the restoration, preservation, and interpretation of railroad history that fueled the growth of Long Island.

3

Get out your sunscreen, because a dozen Long Island beaches are within reach of Flanders. Tourist favorites include **Jones Beach State Park**, **Montauk**, **Fire Island**, **Coopers Beach**, and **Main Beach**.

Get away from the hustle and bustle of the city and disappear into the Hudson Valley. An area rich with agricultural history, the valley led the farm-to-table and local food movements in the 1970s. Other major industries include wine making and tech, both of which nod to the valley's role in the Industrial Revolution. In the nineteenth century, the Hudson River Valley became a port and factory town with easy access to the Hudson River, connecting to the Erie Canal and Great Lakes. The valley's rolling hills and majestic mountains are home to dozens of gardens, nature museums, and natural preserves.

HUDSON VALLEY

SOUTHEASTERN NEW YORK

TOP EXPERIENCES

1
Research **"Haunted Hudson Valley"** to find a range of stories detailing paranormal activity in the region. In Nyack, there is even a home that is *legally* haunted. (Yes, really!)

2
The town of **Hudson** in upstate New York is a haven for artists, foodies, and antiques lovers. Downtown is peppered with a mix of quirky shops and historic buildings, making for a relaxing getaway destination for New Yorkers.

3
Go camping in the **Adirondacks**, where lakeside resorts and wilderness campsites abound.

The Big Apple, the City That Never Sleeps, the Five Boroughs, the Empire City. No matter what you call it, there is no denying the city's influence on culture, finance, fashion, politics, food, and media. New York City is the biggest city in the country and the most linguistically diverse city in the world. Before European explorers landed in New York, the five boroughs and the lower Hudson Valley belonged to the Algonquian people. The next several centuries brought an electric buzz to the city, which became the birthplace of contemporary cultural movements like the Harlem Renaissance, stand-up comedy, abstract expressionism, hip-hop, and punk rock. The city's fast pace and rich history continue to captivate the world today.

NEW YORK CITY

NEW YORK

TOP EXPERIENCES

1. Visit any number of landmarks in the city including the **Statue of Liberty**, **Times Square**, the **Empire State Building**, the **Brooklyn Bridge**, or the **High Line**.

2. Spend a day in **Central Park**. Go boating, take a yoga class, or take a bike tour through the large urban oasis.

3. Explore the **five boroughs**: Manhattan, Brooklyn, the Bronx, Queens, and Staten Island. Which is your favorite?

WEST
VIRGINIA

VIRGINIA

NORTH
CAROLINA

SOUTH
CAROLINA

The Pocono Mountains in northeastern Pennsylvania are a popular recreational destination for millions of people in the New York, New Jersey, Pennsylvania, and Washington, D.C., area. The name Pocono is derived from the Munsee (one of two Lenape languages) word "Pokawachne," which translates to "creek between two hills" or "stream between two mountains." With mountains that overlook the Delaware River, Wyoming Valley, and Lehigh Valley, the area is home to quaint antiquing towns, more than 150 lakes, waterparks, adventure courses, resorts, campsites, and stunning waterfall hikes. The rivers, lakes, and streams in the Poconos are ecological treasures, too, supporting an abundance of marine life including trout, catfish, and bass.

POCONO MOUNTAINS

NORTHEASTERN PENNSYLVANIA

TOP EXPERIENCES

① Visit the sparkling **Lake Wallenpaupack** with its fifty-two-mile-long shoreline, paddle boarding, boating, and hiking trails.

② The mountain towns in the Poconos are peppered with **antiques shops** and **flea markets**, ideal for spending hours rifling through old books, vintage vinyl, quirky ceramics, and local handmade treasures.

③ Take a **Soarin' Eagle Rail Tour** on a rail bike. Rail bikes are pedal-powered carts made to fit the old railroad tracks. Experience six miles of riverside views, lush nature, and mountain history.

The Appalachian Trail, clocking in at more than 2,180 miles and stretching across fourteen states, is the longest hiking-only footpath in the world. In northern Virginia, 101 miles of the trail pass through Shenandoah National Park, a sanctuary for the state's wildlife and home to remarkable geologic formations. Established in 1935 as one of the first eastern national parks, Shenandoah also offers nearly 200,000 acres of backcountry and wilderness camping across Virginia's Blue Ridge Mountains. The park's famous Skyline Drive offers drivers a uniquely intimate view of the Shenandoah Valley in the west and Virginia Piedmont in the east.

SHENANDOAH

NATIONAL PARK

NORTHERN VIRGINIA

TOP EXPERIENCES

1. Take a trip along the rolling hills and valleys of the park on **Skyline Drive**. Make sure to stop at the overlooks to take in the spectacular views.

2. Shenandoah is only seventy-five miles outside **Washington, D.C.**, a metropolis overflowing with museums, monuments, arts, and culture.

3. Go to the **Big Meadows** area at night, where it gets dark enough to stargaze. Though it's not the darkest park in the States, due to its high elevation and distance from dense urban areas Shenandoah is a great place to hunt for stars.

This charming roadside attraction and the pride of Chester, West Virginia, wasn't always a teapot. Its first life was as a giant barrel used for a Hires Root Beer ad campaign in Pennsylvania. Before it found its way to West Virginia, it was repurposed as a small clubhouse for a miniature golf course. In 1938, William "Babe" Devon bought the barrel and shipped it to his pottery shop in Chester, where he added a spout and handle. As pottery business in the region boomed, Devon hired teenagers to work in the fourteen-foot-tall structure, selling concessions and souvenirs outside his shop. The teapot is now a beloved landmark, maintained by the Chester City Council.

THE WORLD'S

LARGEST TEAPOT

CHESTER

WEST VIRGINIA

TOP EXPERIENCES

 1
The teapot is an hour away from Pittsburgh, a city bursting with arts and culture. Visit the **Andy Warhol Museum**, **Mattress Factory** (an avant-garde art gallery), the **Carnegie Museums**, and the quirky artist-owned **Randyland**.

 2
If you're up for a two-hour drive across the Pennsylvania border, you can visit **Frank Lloyd Wright's Fallingwater**, a stunning piece of architectural history.

3
Drive an hour northwest to Alliance, Ohio, and you'll find the **Troll Hole**, an epic troll collection and museum that explores trolls from mythology to the modern day.

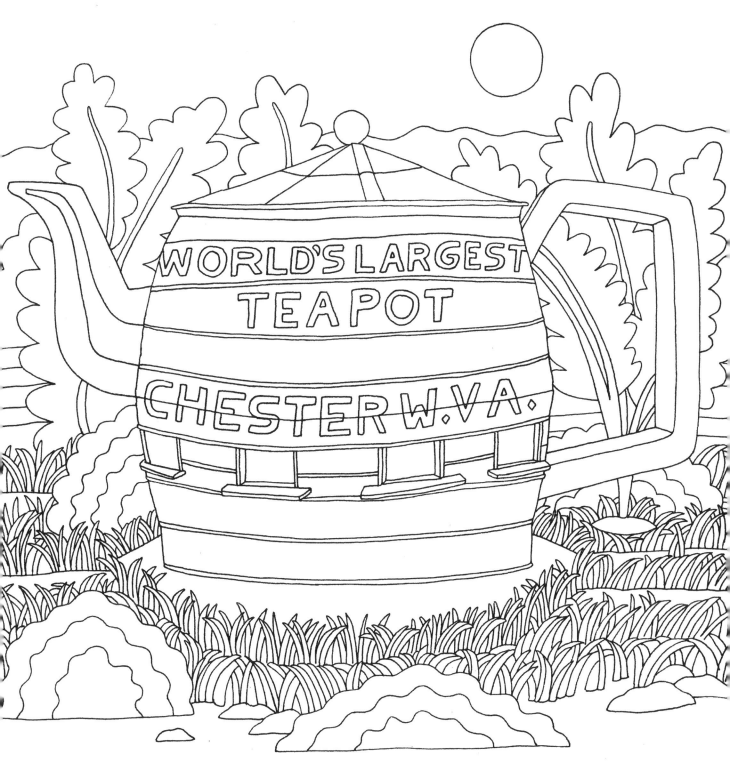

Founded in 1670 as Charles Town, to honor King Charles II, the port city on South Carolina's coast played a significant role in America's slave-trading history. By the 1860s, civil war erupted. The first shots of the American Civil War were fired at Fort Sumter, a seaport built on a small, man-made island meant to protect the city from naval invasion. The city has preserved its cobblestoned streets, hitching posts, and gas lanterns, all of which place tourists in a bygone era, with historic buildings predating the Revolutionary War still intact. Today, Charleston is regarded as one of the friendliest cities to visit in the States.

CHARLESTON

SOUTH CAROLINA

TOP EXPERIENCES

1. Take a guided tour, whether it's a historic trek to **Fort Sumter**, a walk through an antebellum mansion, a graveyard ghost tour, a carriage ride, or an outdoor paddle-boarding adventure.

2. Explore the food scene in **downtown Charleston**. The city boasts a rich culinary history with a variety of influences from Europe, West Africa, and the West Indies combining to create Low-Country flavor.

3. Visit the **Gibbes Museum of Art**, home to a collection of art that illustrates Charleston's complicated history.

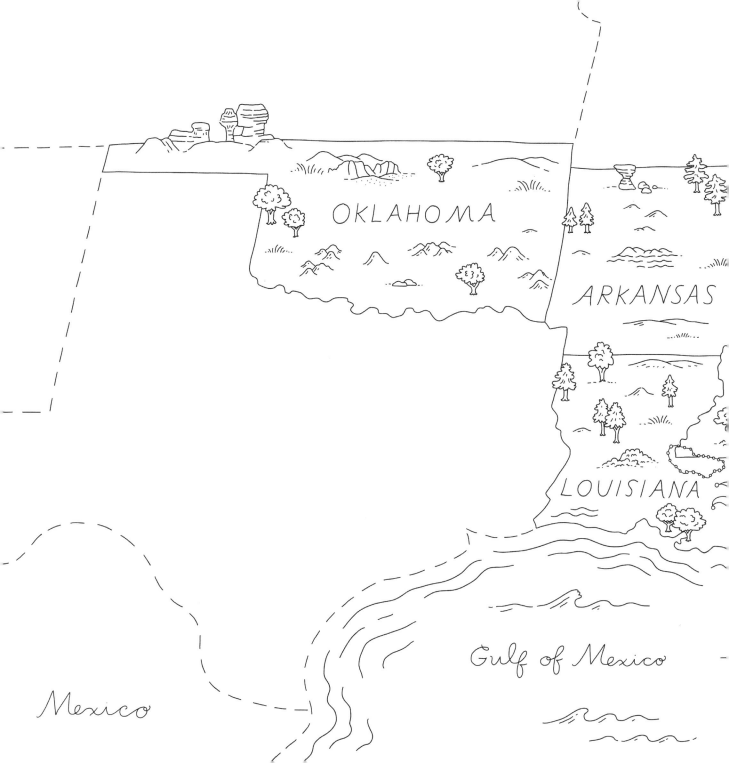

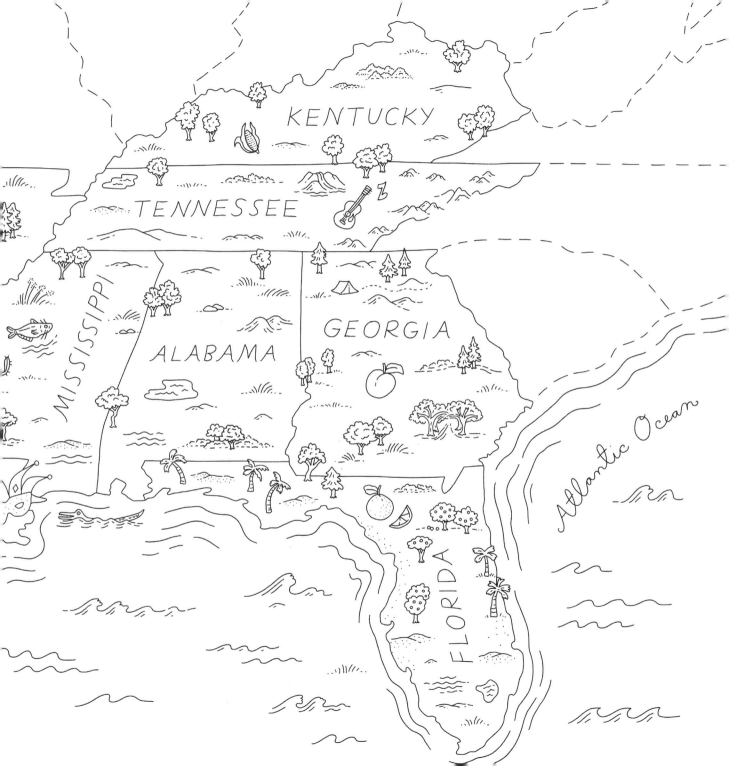

Located amid lush Kentucky forests and the Green River Valley, Mammoth Cave is home to unparalleled biodiversity and nearly every type of cave formation known. The park's labyrinthine caverns and striking limestone topography have been attracting tourists since the nineteenth century. In the 1830s, property owners and enslaved men who worked as tour guides explored the caves together, paving new pathways for tourists, and extending the known length of the underground maze. Explorers continued to add to the cave's mileage through the twentieth century, and Mammoth Cave is now recognized as the longest system of natural caves and underground passageways in the world.

MAMMOTH CAVE
NATIONAL PARK

EDMONSON, HART, AND

BARREN COUNTIES

KENTUCKY

TOP EXPERIENCES

 1

Take a ranger-led **cave tour** and see how many unique species and geologic formations you can identify. The caves are teeming with stalagmites and stalactites; crickets, opossums, salamanders, and bats; gypsum flowers, columbines, and rare mirabilite flowers.

 2

Check out the **Green and Nolin Rivers**, which are some of the most biodiverse rivers in the United States. There are thirty-six miles of waterways to travel by canoe, kayak, or paddleboat!

3

Hike **Cedar Sink Trail** and marvel at the incredible variety of wildflowers on your trek. For those who enjoy backcountry hikes, dozens of other trails full of adventure await.

Ninety miles north of Atlanta lies Georgia's Blue Ridge, a mountain town and lakeside escape for residents of Georgia, Tennessee, and North Carolina. Blue Ridge was founded in 1886, when the Marietta and North Georgia Railroad made its way through the center of town, cementing the small community as a center of business. The town was once an elite health resort destination for folks who sought the benefits of the town's pure mineral waters. Now the region bustles with outdoor recreation, a thriving arts community, orchards, breweries, and gorgeous scenic drives through the Chattahoochee National Forest.

BLUE RIDGE

GEORGIA

TOP EXPERIENCES

1. Hike to **Long Creek Falls in Fannin County**, one of the most popular falls in the area.
2. Take a ride on the historic **Blue Ridge Scenic Railway** along the Toccoa River to McCaysville, where you can stand along the Tennessee-Georgia border and be in two states at once!
3. Paddle down the **Toccoa River Canoe Trail** to the longest swinging bridge east of the Mississippi River. The views from the bridge are divine.

The Everglades is the largest natural region of tropical wilderness in the United States, only part of which is protected by Everglades National Park. Named the "River of Grass" by the Native Calusa and Tequesta tribes, the Everglades is a marshy wetland dotted with forests and teeming with unique ecosystems in ponds, sloughs, mangroves, and sawgrass marshes. After a period of overdevelopment coinciding with the Industrial Revolution, conservationists have worked for more than a hundred years to restore and protect the park from further damage. Though the Everglades encompasses more than a million acres of wilderness, the national park was established in 1947 to preserve the southernmost 20 percent of the fragile ecosystem.

EVERGLADES

NATIONAL PARK

SOUTHERN FLORIDA

TOP EXPERIENCES

1

Get your feet wet with a tour guide on a **slough slog**—a trek through the wetlands to a forested freshwater wetland called a cypress dome.

2

Look for the elusive **Florida panther**, **American alligators**, **West Indian manatees**, **foxes**, **geckos**, **bats**, **turtles**, **herons**, **egrets**, and more of the unique species that call the wetlands home.

3

Everglades National Park is an hour drive from **Miami**, a city known for its towering skyline, tropical beaches, and tourist attractions.

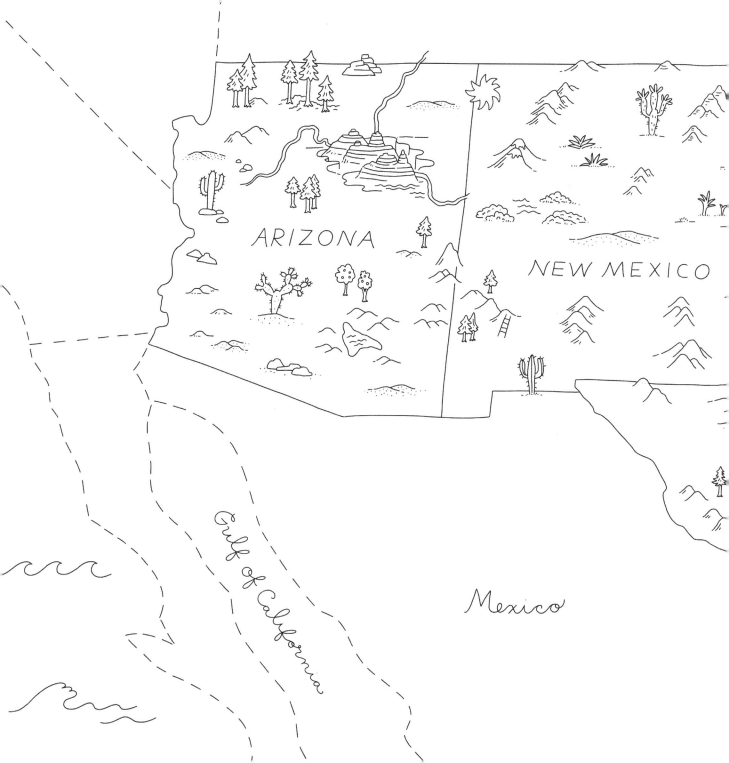

ARIZONA

NEW MEXICO

Gulf of California

Mexico

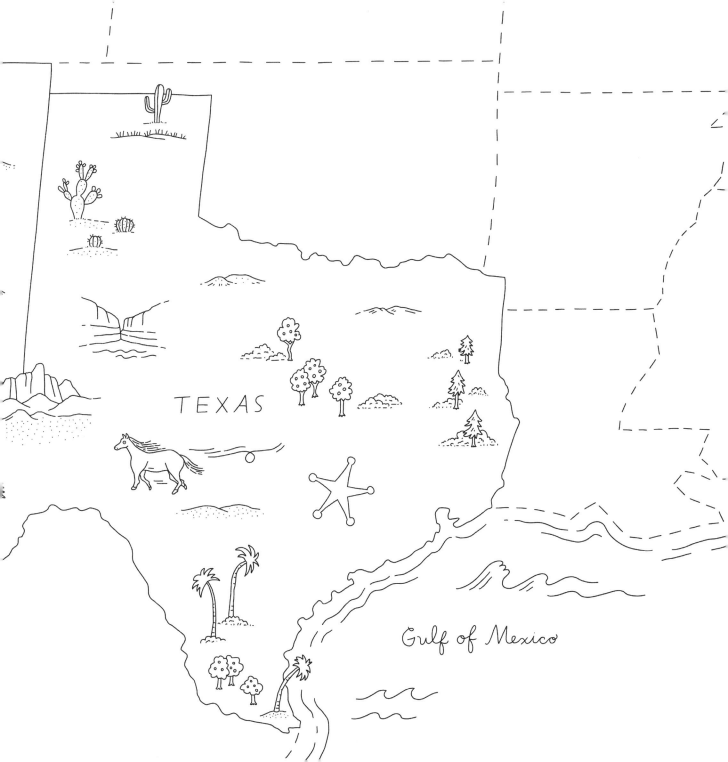

TEXAS

Gulf of Mexico

The Grand Canyon, one of the seven natural wonders of the world, is a stunning display of nearly two million years of our planet's geologic history. The sheer scale of the canyon is near impossible to grasp, even as you hike down into the gorge, experiencing the terrain's deafening quiet and vast vistas. For thousands of years, a number of distinct Native tribes revered and inhabited the canyon, learning from the land long before Spanish explorers and European settlers colonized the region. The National Park Service reports a total of eleven contemporary tribes that have cultural ties to the Grand Canyon and is committed to protecting and preserving all of the human history and culture found within the park.

GRAND CANYON

NATIONAL PARK

NORTHERN ARIZONA

TOP EXPERIENCES

1 Snapping photos from the hikeable **Rim Trail** is a bucket list item for most who travel to the Grand Canyon.

2 Hike down the **Grand Staircase** and look for fossilized marine creatures, animal tracks, and ferns. Learn more about the canyon's history at **Yavapai Museum of Geology** on the South Rim.

3 The South Rim is also dotted with historic buildings that capture the stories of American miners, a pair of brothers who photographed visitors for a living, the Hopi people, female architect Mary Colter, and the **Grand Canyon Railway**.

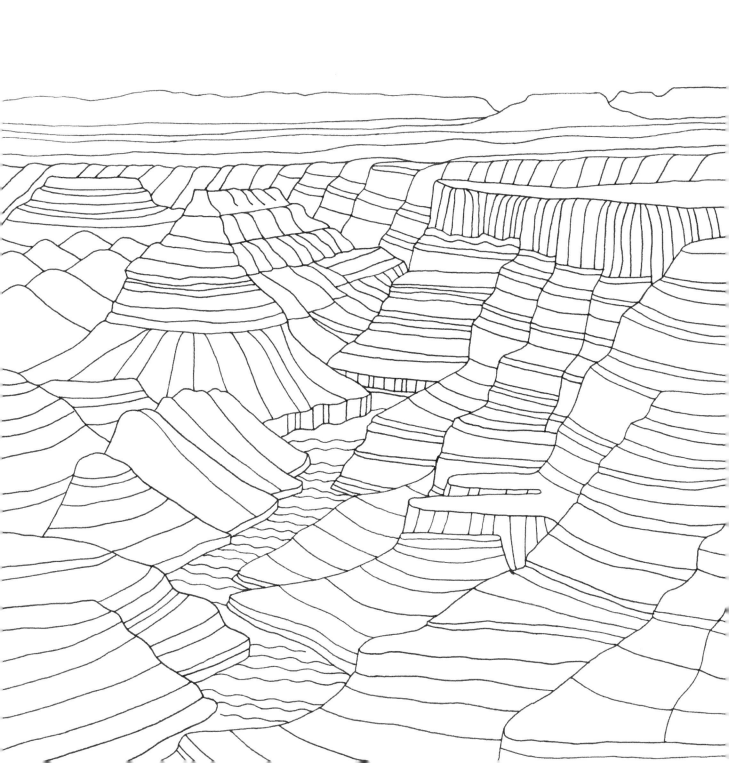

Saguaro National Park's namesake is the saguaro cactus, the largest cactus in the country. These desert plants have become a distinct symbol of the American West, and the national park was created to preserve the enormous cacti and the Sonoran Desert ecosystem. In 1994, Congress established Saguaro National Park by designating two separate tracts of land—the Tucson Mountain District just west of the city and the Rincon Mountain District in the east—as a single preservation site, aimed at protecting the Sonoran Desert ecosystem. Today, the park is home to more than 450 archaeological sites and more than 60 historic structures that delve into the history of its Native ancestors and natural life.

SAGUARO NATIONAL PARK

PIMA COUNTY

ARIZONA

TOP EXPERIENCES

 1

Hike the **Loma Verde Loop**, a relatively easy trail, and see if you spot any roadrunners or wild boars!

 2

View the sunset from one of the National Park Service's recommended overlooks: **Tanque Verde Ridge Trail**, the **Javelina Rocks** pullout, or **Gates Pass**, at the end of **Speedway Boulevard**.

3

Be on the lookout for what the National Park Service, or NPS, calls **"NPS rustic" architecture**. Rugged shelters, dams, and even furniture constructed with rocks and other Native materials can be spotted throughout both sides of the park.

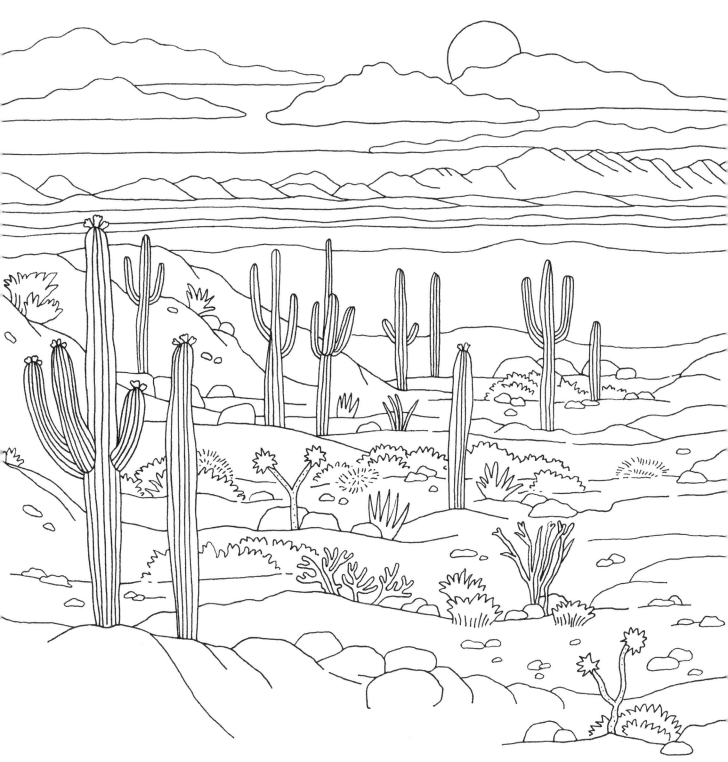

The illustrious modern artist Georgia O'Keeffe traveled all over the country before falling in love with New Mexico. In the late 1920s, the famous painter explored the rugged terrain of Taos, where she was inspired by the stark landscape, Native American influences, and Hispanic cultures of the region. Some of her most famous works—*Ram's Head*, *White Hollyhock-Hills*, and *Summer Days*—were painted using sun-bleached animal skull souvenirs as her primary subjects. O'Keeffe began driving across the northern part of the state, a peaceful place she romanticized, calling it "the faraway." By the 1940s, the artist made the village of Abiquiú, sixty miles northwest of Santa Fe, her home.

GEORGIA O'KEEFFE

HOUSE MUSEUM

ABIQUIÚ

NEW MEXICO

TOP EXPERIENCES

(1) Take a **behind-the-scenes tour** of Georgia O'Keeffe's home and studio to get special access to her bedroom, her closet, and the *salita* where she prepared her canvases.

(2) Too far from New Mexico to visit? You can take an **online watercolor class** through the museum's education program!

3 Spend a day in **downtown Taos**, where O'Keeffe first landed in New Mexico. The historic district is close to a handful of art and history museums, quirky cafés, and stunning biotecture communities you won't want to miss.

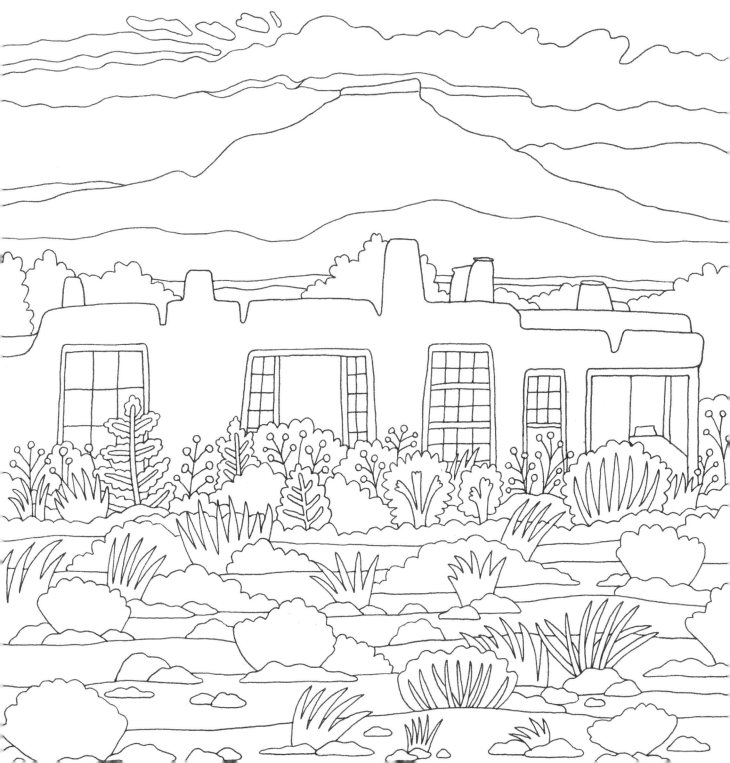

The otherworldly, glistening white sand dunes of the Tularosa Basin are something out of a sci-fi film. Giant undulating waves of gypsum sand cover 275 square miles of desert, where tourists go dune sledding, sunbathing, hiking, biking, and picnicking as they enjoy the view. White Sands National Park preserves much of the world's largest gypsum dune field, along with the plants and thousands of animal species that call the sand home. The Tularosa Basin has attracted people for more than ten thousand years, from the nomadic hunters who lived during the last ice age to the bands of Apache people who established and defended a sizable territory from the Spanish explorers in the nineteenth century and beyond.

WHITE SANDS

NATIONAL PARK

OTERO AND DOÑA ANA COUNTIES

NEW MEXICO

TOP EXPERIENCES

1. The white dunes of the park sometimes look like snow mounds, so the park welcomes tourists to **sled down** the shimmering white hills. Purchase a waxed plastic saucer at the park's gift shop for the experience of a lifetime.

2. Take the scenic route down **Dunes Drive**, a curvy eight-mile route that cuts through the dunes.

3. Hike the **Dune Life Nature Trail**, a family-friendly path with trailside information about the most diverse ecosystem in the park. Don't forget to bring your water!

Many Austinites have embraced the slogan "Keep Austin Weird" as a plea to maintain the bohemian eccentricity of this capital city bursting with small-town charm. Since 2010, Austin has been touted as one of the fastest-growing large cities in the United States, and it is home to a diverse mix of government employees, college students, musicians, tech workers, and blue-collar workers. The internationally acclaimed music festivals South by Southwest and Austin City Limits call Austin their stomping grounds, making it easy to see why the city is the Live Music Capital of the World.

AUSTIN

TEXAS

TOP EXPERIENCES

1

Austin boasts more than fifty public pools and swimming holes, including the nation's largest natural swimming pool in an urban area, **Barton Springs Pool**. Other favorite spots to take a dip include **Lake Travis**, **Lady Bird Lake**, and **Deep Eddy**.

2

Annual cultural events include the **O. Henry Pun-Off**, **Eeyore's Birthday Party**, **Spamarama**, **Austin Pride**, the **Austin Reggae Festival**, the **Pecan Street Festival**, and several music and film festivals.

3

Visit the Instagram-worthy **Willie Nelson statue**, the *Hi, How Are You* mural by Daniel Johnston, or the *Greetings from Austin* mural on the south side of the Roadhouse Relics building.

This national park's namesake is a sharp bend in the Rio Grande that hugs the Mexican border on the southwest side of Texas. Big Bend National Park protects the river's habitats as well as the ecology of the Chihuahuan Desert, which stretches across the U.S. border into northern Mexico. The Chisos Mountains also reside in Big Bend and are the only American mountain range to be fully contained within the boundary of a national park. Hundreds of archaeological sites capture the cultural history of the region, from the Paleo-Indian period and sixteenth-century Spanish expeditions to modern settlers who worked as miners, ranchers, and farmers in the area before it was officially established as a national park in 1944.

BIG BEND NATIONAL PARK

CHIHUAHUAN DESERT

TEXAS

TOP EXPERIENCES

(1)

Big Bend is home to more species of **cactus** than any other national park. See how many you can identify!

If you're looking to take a dip in ancient hot spring water, take the **Hot Springs Historic Trail**, where the remains of an old bathhouse provide hikers with a unique geothermal bathing experience.

3

Paddle upstream from the **Santa Elena Canyon Trailhead** to get up close and personal with the dramatic canyon cliffs on the Mexican border.

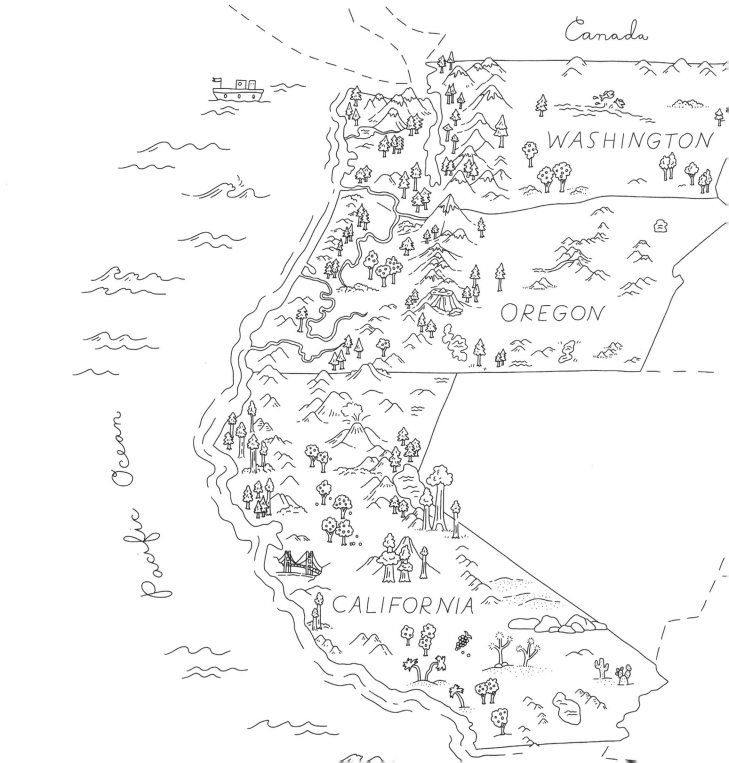

Just east of Los Angeles and north of Palm Springs, two distinct desert ecosystems meet in Joshua Tree National Park. The two deserts differ mostly due to elevation, with the Mojave sitting higher on the east and the lower-altitude Colorado on the west side of the park. The Mojave is home to the yucca tree for which the park is named: a twisty, Seussian member of the agave family that flowers just once a year. The Colorado Desert is dotted with creosote bushes, cholla cacti, and ocotillos. Desert animals like kangaroo rats, coyotes, desert spiny lizards, ravens, and red-tailed hawks can be spotted in the hot, dry climate among the flora.

JOSHUA TREE NATIONAL PARK

RIVERSIDE AND

SAN BERNARDINO COUNTIES

CALIFORNIA

TOP EXPERIENCES

1. Visit **Pioneertown**, a Hollywood Western movie set built in 1946. The set resembles an 1870s frontier town. Give your best cowboy impersonation a shot.

2. At the top of the Little San Bernardino Mountains, **Keys View** is an overlook that offers incredible views of the Coachella Valley.

3. Joshua Tree is home to more than 241,000 objects in its **museum collections**, including historic relics from Pinto culture; the Cahuilla, Chemehuevi, and Serrano tribes; and tools and children's toys from the gold rush and ranching eras.

The sight of the Golden Gate Bridge beckons visitors into the heart of San Francisco, a city of cultural rebellion, historic landmarks, and natural beauty. The city is home to more than a dozen distinct neighborhoods, each with its own identity and unique heritage. The oldest Japantown in the country rests below one of the highest points in the city, Nob Hill. The Castro, known as the LGBTQ+ capital of the world, borders the Haight, the birthplace of the counterculture revolution of the 1960s. Shop in Union Square, museum-hop in SoMa, and soak up the music scene in Fillmore. No matter where you end up, San Francisco greets visitors with top-notch food, stunning views, and an endless loop of events celebrating the diverse culture of the Golden City.

SAN FRANCISCO

CALIFORNIA

TOP EXPERIENCES

 1

As you climb the notoriously steep streets of the city, soak up the views. Some great lookout spots are **Twin Peaks**, **Coit Tower**, **Alamo Square park**, and **Hawk Hill**.

 2

Wander through the **Mission District** and pay a visit to its namesake, the eighteenth-century Spanish Californian mission (and oldest structure in San Francisco), **Mission Dolores**.

3

Take a breath of fresh California air at **Golden Gate Park**. While you're there, visit the **de Young Museum**, bird-watch near **Middle Lake**, ride the **SkyStar Wheel**, or people-watch on **Hippie Hill**.

Mount Tamalpais, affectionately known by locals as Mount Tam, is a 2,571-foot peak that overlooks San Francisco and the Farallon Islands off the coast of the city. The state park is home to the Muir Woods National Monument, a protected old-growth redwood forest named after the naturalist John Muir. In addition to the redwood forests, the park is blanketed with oak woodlands, open grasslands, and chaparral. A large open-air amphitheater hosts outdoor performances and astronomy classes, and the park accommodates campers, hikers, and bikers year-round.

MOUNT TAMALPAIS

STATE PARK

MARIN COUNTY

CALIFORNIA

TOP EXPERIENCES

 1

Reserve one of the **Steep Ravine cabins**—a cluster of ten wooden residences from the 1940s with no electricity on the coast of Bolinas Bay just north of Muir Beach.

 2

Hike the trails at the **Ring Mountain Preserve**, along the ridge of the Tiburon Peninsula. In addition to blankets of rare and endangered plant species, the preserve is home to petroglyphs archaeologists believe came from the Coast Miwok people.

3

Zip over to **Sonoma Valley** to visit historic vineyards, community farms, and a downtown scene that offers irresistible wine tastings and gourmet feasts.

The granite cliffs, sparkling waterfalls, and centuries-old trees of Yosemite are the stuff national parks are made of. Contemporary history of the area tends to begin with the 1849 gold rush, when non-natives flooded California in search of gold and financial freedom. As European Americans settled in Yosemite Valley, word spread of the beauty of the Sierra Nevada, bringing artists and tourists to the area in droves. By 1864, the federal government acknowledged the value of a federally preserved land, and by 1890, Congress established Yosemite as a national park, paving the way for the National Park System we know today.

YOSEMITE NATIONAL PARK

TUOLUMNE, MARIPOSA, MONO,

AND MADERA COUNTIES

CALIFORNIA

TOP EXPERIENCES

1. Visit **Mariposa Grove** to see over five hundred sequoias packed into a 250-acre parcel of land. Look for specific trees like the Fallen Monarch and Clothespin Tree.

2. The best time to visit the waterfalls in Yosemite is during the spring, when snowmelt occurs. Check out **Yosemite Falls**, **Sentinel Falls**, and **Ribbon Fall**.

3. Rock climbers from all over the world travel to Yosemite. If you're up for a climb, the **Yosemite Mountaineering School and Guide Service** offers classes for all experience levels.

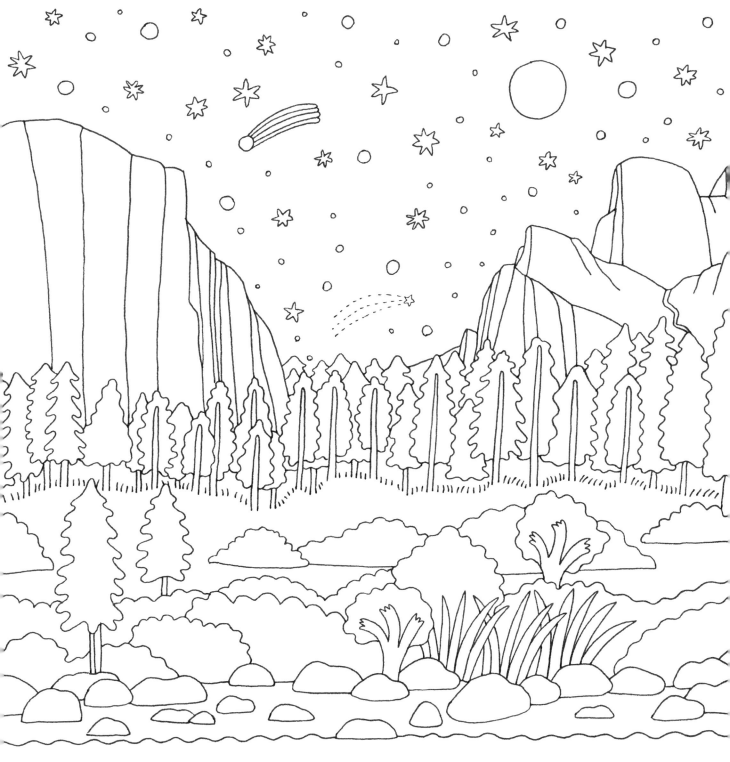

The Pacific Northwest (PNW), with its lush forests, whale watching, snowcapped mountains, and vibrant arts and food culture, is celebrated as an outdoor adventurer's paradise. Though the borders of the area are not clearly defined, the mention of the PNW evokes images of craggy mountain hikes, pristine lakes, endless wildflower meadows, environmentally conscious communities, indie music culture, and a mountain-based sports haven for skiers, snowboarders, cyclists, and hikers.

THE PACIFIC NORTHWEST

OREGON, WASHINGTON, IDAHO,

AND NORTHERN CALIFORNIA

TOP EXPERIENCES

 1

Mount Rainier National Park in southern Washington is a natural wonder to behold. The icy volcano is blanketed with subalpine wildflower meadows and ancient forests. Outdoor adventurers flock to the area to breathe the fresh mountain air.

 2

Taste some of the country's best wine in one of the four hundred **wineries** that dot the **Willamette Valley** in Oregon.

 3

If you make it up to Seattle, check out **Pike Place Market**, a waterfront farmers market vibrating with gourmet innovation. The original Starbucks is just across the street!

The largest cowboy hat and boots in America were once a roadside advertisement for a western-themed gas station named Hat 'n' Boots. Though the gas station shuttered in the late 1980s, the community lassoed enough money to save the iconic attraction from decay and preserve it as a piece of local history. The forty-four-foot-wide hat was originally built to hold the gas station's office, and the boots served as public restrooms. The destination made a cameo in *National Lampoon's Vacation* and has since been moved to Oxbow Park in the Georgetown neighborhood of the city.

HAT 'N' BOOTS

SEATTLE

WASHINGTON

TOP EXPERIENCES

① Seattle is rife with photographable oddities, from a **mural-esque chewing-gum-covered wall** to the city's **pinball machine** and **pop culture museums**, there is something for everyone to enjoy.

 Catch stunning views of Mount Rainier and Puget Sound from **Myrtle Edwards Park**, a serene bay-front beach with a bike trail next to the **Olympic Sculpture Park**.

③ Seattle's famous **Space Needle** was a Jetsons-like tower built for the 1962 World's Fair. Zip up to the observation deck for stunning views of the city.

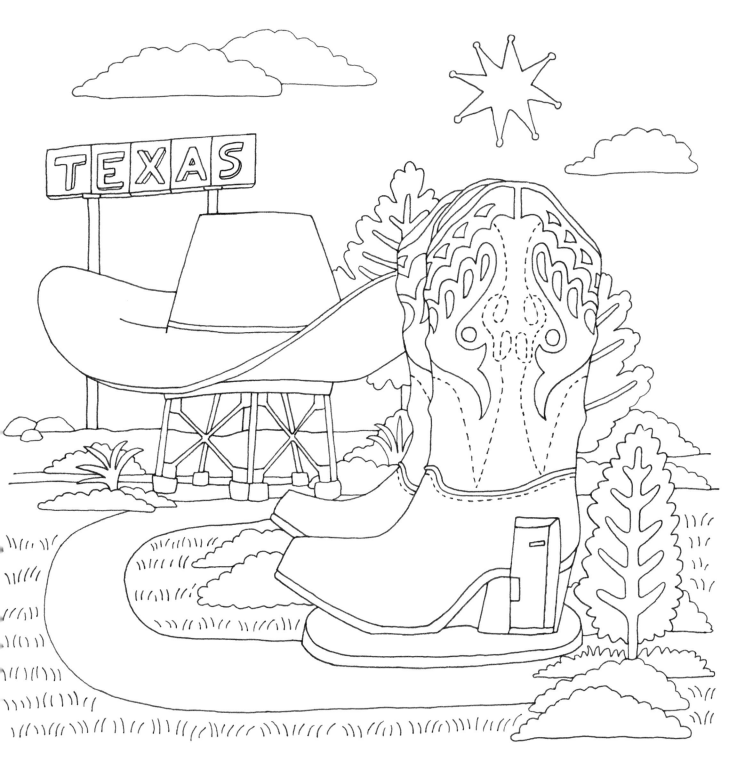

Pacific Ocean

IDAHO

NEVADA

UTAH

The unparalleled beauty of Mesa Verde National Park, with its sloping mesas and rugged canyons, is made even more impressive with the ancient ruins of Ancestral Puebloans' cliffside cave dwellings. The largest archaeological preserve in the country, Mesa Verde National Park was established in 1906 and has successfully preserved six hundred cave dwellings (built between AD 650 and AD 1285) and more than five thousand archaeological sites. The park is revered as an ancestral home to twenty-six contemporary Native tribes across Colorado, Arizona, New Mexico, Texas, and Utah.

MESA VERDE

NATIONAL PARK

MONTEZUMA COUNTY

COLORADO

TOP EXPERIENCES

1. Visit the **Chapin Mesa Museum** before venturing into the park to learn about the ancient civilization that once thrived on the mesa.

2. Take a ranger-assisted tour of **Cliff Palace**, a stunning piece of ancient architecture that provided shelter and community for more than one hundred people.

3. Hike the trails of **Morefield Canyon**, **Chapin Mesa**, or **Wetherill Mesa** and marvel at the mesa-top villages, towers, dams, and petroglyphs while taking in the expansive views.

Rocky Mountain National Park offers visitors the chance to experience wet, grassy valleys, wildflower-dotted meadows, alpine tundra, and breathtaking views from some of the highest peaks in the country, all in one place. The Rockies stretch from northern British Columbia down to Albuquerque, New Mexico, the park itself is nested between the towns of Estes Park and Grand Lake, Colorado; the state is home to the mountain range's thirty highest peaks. The park protects historic trails, buildings, and roads in addition to the vast wildlife. Though English settlers originally thought the Rockies were impenetrable, they eventually found and reinforced paths created by the Ute and Arapaho tribes who lived off the land for hundreds of years prior.

ROCKY MOUNTAIN NATIONAL PARK

LARIMER, GRAND, AND

BOULDER COUNTIES

COLORADO

TOP EXPERIENCES

1

Catch a glimpse of the **wild animals** that roam the park, from bighorn sheep, moose, and elk to marmots and otters. Snap pictures and be sure to keep your distance!

2

Visit **Alpine Visitor Center** along **Trail Ridge Road** (a highway to the sky listed on the National Register of Historic Places), the highest visitor center in the National Park System.

3

Book a room at the historic **Stanley Hotel**, opened in 1909, which was the setting for Stephen King's *The Shining*.

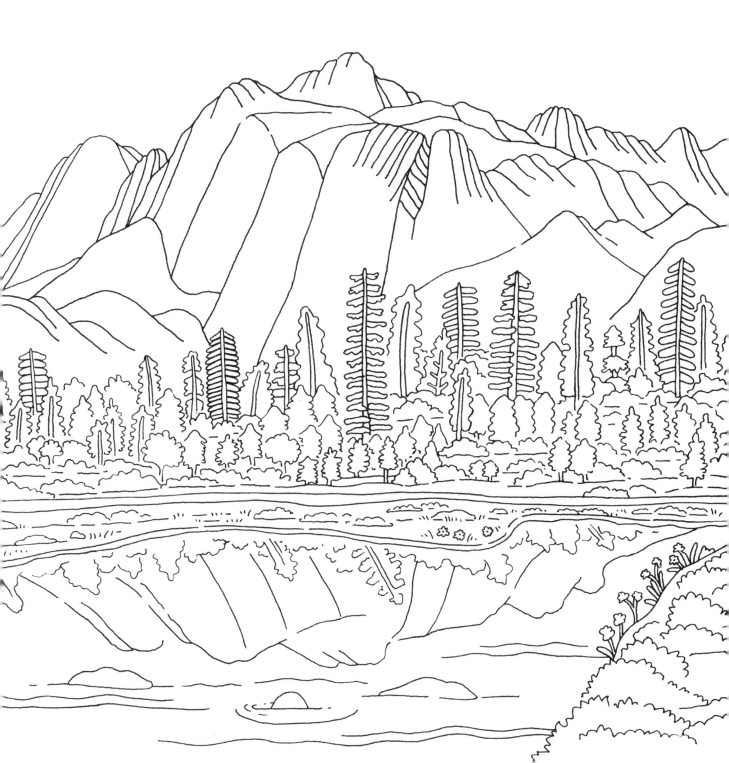

Dog Bark Park Inn may just be the bed-and-breakfast you never knew you needed. In Cottonwood, Idaho, along U.S. Route 95, the chain-saw artist Dennis J. Sullivan decided to build a twelve-foot-tall beagle to draw curious travelers into town. As his folk-art business boomed, Sullivan's dreams grew . . . and a second beagle, Sweet Willy, was born. At thirty feet tall, the giant dog-shaped inn contains a bedroom, bathroom, and loft space, with a wooden deck perched on the outside. Sullivan and his wife, Frances Conklin, have decorated the park with other wooden creations, too: a large toaster with slices of bread inside, a percolator (meant to hold Sullivan's coffeepot collection someday), and a fire hydrant, complete with a porta potty.

THE WORLD'S

LARGEST BEAGLE

COTTONWOOD

IDAHO

TOP EXPERIENCES

1

If you're up for another quirky overnight stay, four hours south of Sweet Willy lies the **Big Idaho Potato Hotel**, a giant spud with a single bedroom inside. The neighboring silo is home to a spa-bathroom and working fireplace.

2

On the western side of the state lies the **Idaho Potato Museum** and **Potato Station Cafe**, which serves baked potatoes, potato chips, French fries, and homemade potato bread.

3

Idaho is rife with **ghost towns**. In the aftermath of the 1849 gold rush, many mining towns were abandoned. Today, several cities have restored late-nineteenth-century buildings to celebrate the mining history of the Wild West of yore.

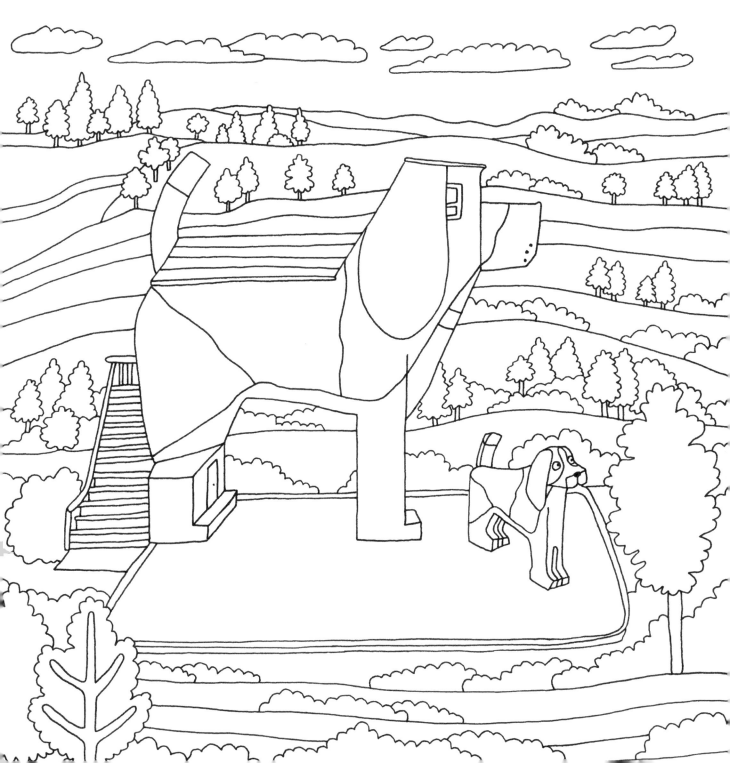

Glacier National Park straddles the Canada-U.S. border, stretching from Montana into Alberta and British Columbia, covering more than a million acres of forests, lakes, and breathtaking mountain ranges. The park's behemoth mountains were carved by the glaciers of the last ice age. Almost all of the region's original native plant and animal species still inhabit the park—from grizzly bears, moose, and wolverines to the red cedar and hemlock that populate the forests. Of the 150 glaciers that existed in the mid-nineteenth century, however, only 25 of them remained in 2010. The pristine, glittering landscape endures, bringing three million visitors to its mountains every year.

GLACIER NATIONAL PARK

FLATHEAD AND

GLACIER COUNTIES

MONTANA

TOP EXPERIENCES

1. Catch a glimpse of the best scenery the park has to offer by driving up the winding twists of **Going-to-the-Sun Road**. Watch out for mountain goats!

2. **Huckleberries** run rampant on the hills of Glacier National Park. Check with your local ranger about when and where berries can be found.

3. Check out **Native America Speaks**, a series of presentations from tribe members of the Blackfeet, Kootenai, Pend d'Oreille, and Salish Nations. Presenters share about their culture and heritage through storytelling, singing, and hands-on learning.

Just a few miles north of Moab lies a national park with more than two thousand natural sandstone arches carved by the elements over thousands of years. Arches National Park is host to extraordinary geology; in addition to the arches, visitors may come across natural bridges, windows, spires, and balanced rocks. These formations were first brought to the National Park Service's attention by a railroad traffic manager back in 1923. Geologists and government officials came to the site and were astonished by the landscape. In late 1929, President Herbert Hoover proclaimed the area Arches National Monument. It became an official national park in 1971.

ARCHES NATIONAL PARK

GRAND COUNTY

UTAH

TOP EXPERIENCES

 1

Trek to the iconic **Delicate Arch**, the fifty-two-foot-tall landmark pictured on Utah license plates! Other features to check out include **Landscape Arch**, **Balanced Rock**, **Courthouse Towers**, and **Devils Garden**.

 2

Sign up for a ranger-led tour through the **Fiery Furnace**, a strenuous hike with no trail markings that winds through narrow red-rock alleys, across rickety sandstone ledges, and over rocky drop-offs.

 3

Enjoy the clear night skies and **stargaze** in the park after dark. Arches National Park is designated an official International Dark Sky Park. Due to its relative isolation from major cities and artificial light, the starry skies are visible to the naked eye.

Utah's first national park features stunning canyons, dramatic cliffs, rocky slopes, and sweeping plateaus made from Navajo sandstone, limestone, loose clay, and a near-supernatural, layered rainbow of other rocks. The geologic formations in Zion are part of a super-sequence of canyons and ridges called the Grand Staircase that stretches from Bryce Canyon, just north of Zion, down into Arizona's Grand Canyon. Thousands of years ago, early farmers and hunters made the plateaus of Zion home; these wide, level stretches of land offered farmers a place to grow food alongside a water source. The diverse biology of the park, with its forests, waterfalls, and deserts, provides a home to a rich community of plants and animals still today.

ZION NATIONAL PARK

WASHINGTON, KANE, AND

IRON COUNTIES

UTAH

TOP EXPERIENCES

① Hike the **Narrows**, a colossal gorge through which the Virgin River runs. You'll get your feet wet!

 Spend time in **Kolob Canyons** bird-watching. Zion is home to almost three hundred unique bird species throughout the year. Print out a bird list from the National Park Service's website before you go.

③ Zion is an International Dark Sky Park, a place with uniquely clear skies that makes for a memorable night of stargazing. Popular spots to watch the night sky include **Pa'rus Trail**, **South and Watchman Campgrounds**, and the **Kolob Canyons Viewpoint**.

Just thirty minutes from the Idaho border lies Jackson Hole, a lush valley between the Gros Ventre and Teton mountain ranges in Wyoming. Jackson Hole, which is part of Grand Teton National Park, is almost entirely enclosed by its surrounding mountains, making it feel like a meadowed oasis. The first people to settle the region were Native Americans, including tribes such as the Shoshone, Bannock, Blackfoot, Crow, Flathead, Gros Ventre, and Nez Perce. The summers offered tribes a rich harvest of bulbs and berries and ample grounds for fishing and hunting. European American fur trappers, explorers, and homesteaders soon overtook the region, paving the way for would-be cowboy adventurers and ranchers.

JACKSON HOLE

JACKSON

WYOMING

TOP EXPERIENCES

1. Hike up to the **Phelps Lake Overlook** or take the **Jenny Lake Loop** for unbelievable views and photo ops.

2. Be on the lookout for **pronghorn**—antelope-like creatures that are the sole North American survivor of a family of mammals that has only two other living branches (giraffes and okapis). Pronghorn are almost as fast as cheetahs, running at speeds up to forty-five or fifty miles per hour.

3. Take a break from the mountains in **downtown Jackson**, with its lively saloons, covered wooden walkways, museums, shopping, and cable car rides.

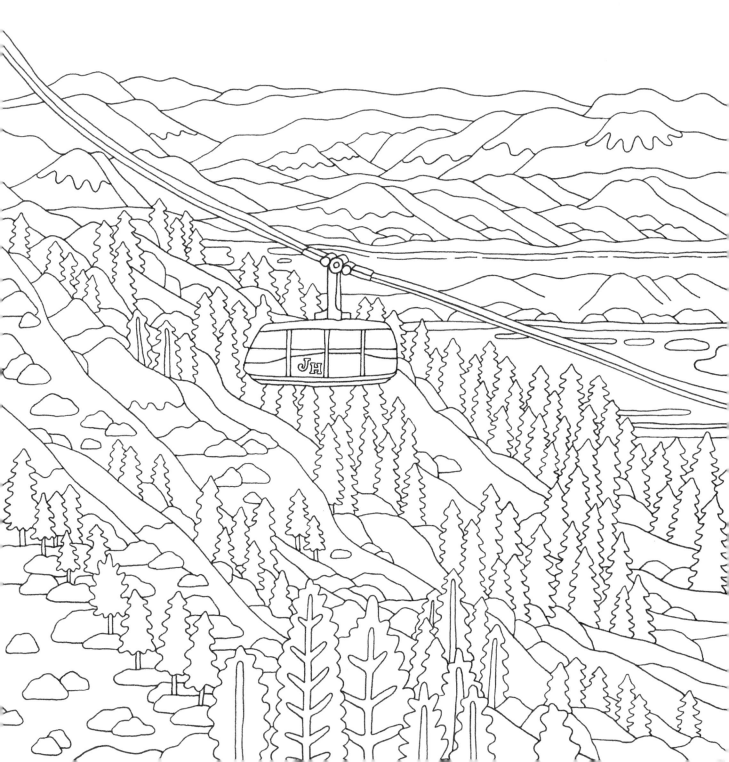

On March 1, 1872, Yellowstone was established as the country's first national park. The park, named after the Yellowstone River, is a stunning preserve featuring about half the world's active geysers; one of the largest, nearly intact temperate-zone ecosystems on the planet; and a diverse range of terrestrial and aquatic life. The park sits directly atop one of the largest active volcanoes in the world, which is largely responsible for the ten thousand thermal features of the park, including geyser basins, hot springs, mud pots, and steam vents. Yellowstone is also known for its unbelievable wildlife, ancient glacial deposits, cascading waterfalls, and cultural history, attracting more than four million visitors annually.

YELLOWSTONE

NATIONAL PARK

WYOMING, MONTANA,

AND IDAHO

TOP EXPERIENCES

Watch **Old Faithful** erupt! The park's most famous geyser is watched closely by the rangers, who predict the timing of eruptions pretty accurately, within a margin of about ten minutes. Check out the **Old Faithful Visitor Education Center**, too, to learn about the forces behind the geyser.

Get a bird's-eye view of Yellowstone by **ziplining** or **riding in a tram** or chair lift in Big Sky or Jackson Hole.

3

Take a **guided trip** through the park **on horseback**. There are also local outfitters who offer llama or mule rides through Yellowstone's meadows, flats, and fields.

At seven stories tall and more than two hundred feet wide, this colossal picnic basket was originally built to be an office building for the basket manufacturer Longaberger Company. The building rests about forty miles outside Columbus. Despite warnings from architects and bankers, the company's founder, Dave Longaberger, said, "If they can put a man on the moon, they can certainly build a building that's shaped like a basket." The interior is surprisingly elegant, with marble floors, a grand staircase, and a player piano in the lobby.

WORLD'S LARGEST

PICNIC BASKET

NEWARK

OHIO

TOP EXPERIENCES

①
Take a tour of the **Olentangy Caverns** just outside Columbus, Ohio.

Visit America's Canal Town, the historic **Roscoe Village**, to learn about life in an 1830s port community.

3
Visit **Otherworld**, an immersive art installation that throws visitors into a surreal, fantastical world of bioluminescent dreamscapes, alien flora, and secret passageways. It's an experience like no other.

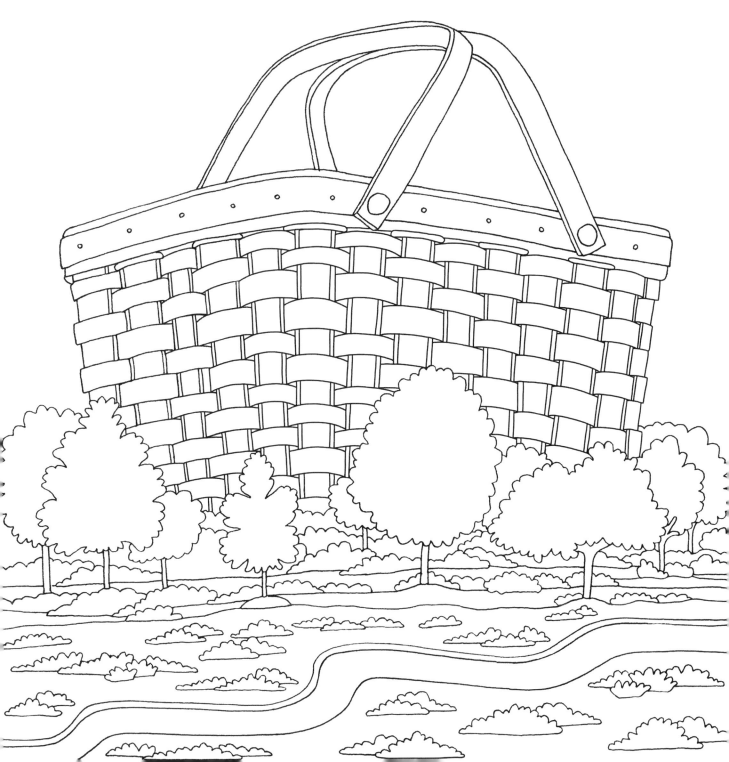

The rugged canyons and staggering buttes of South Dakota's Badlands National Park are home to a seventy-five-million-year-old fossil record, archaeological finds dating back twelve thousand years, and a diversity of wildlife including bison, bighorn sheep, prairie dogs, and the endangered black-footed ferret. The park's archaeological sites contain bison and ancient rhino bones, scorched rock and charcoal indicative of campfires, clay pottery, and signs of quarrying and tools made of stone. With a dearth of drinkable water, all this evidence of early life points to ancient people using the land seasonally, for hunting rather than permanent habitation. The Lakota people called the area "mako sica," translating literally to "bad lands."

BADLANDS NATIONAL PARK

OGLALA LAKOTA, JACKSON,

AND PENNINGTON COUNTIES

SOUTH DAKOTA

TOP EXPERIENCES

1. Spend time **watching the sun set** by the buttes of the park. The stripy, layered rock formations against a glowing sky are something to behold.

2. Drive the park's most popular road, **Badlands Loop Road**, for the scenic views, informational exhibits along the way, and wildlife spotting.

3. If you visit Badlands in the summer, check the calendar for the **Badlands Astronomy Festival**. Educators, astronomers, and space science specialists flock to the park for a host of activities, speakers, and stargazing opportunities.

The massive cave at the heart of this park contains almost 150 miles of pathways—a vast underground labyrinth hidden under wild mixed-grass prairies. Wind Cave, the third-longest cave in the United States, got its contemporary name from the barometric winds that flow in and out of the cave's natural opening due to changes in air pressure. Before the Wind Cave was discovered by white American explorers, Lakota oral tradition referred to a sacred space—a "hole that breathes cool air"—from which humans first emerged. Though the stories passed down from generation to generation vary slightly, Wind Cave is largely believed to be part of this Lakota origin story.

WIND CAVE NATIONAL PARK

CUSTER COUNTY

SOUTH DAKOTA

TOP EXPERIENCES

 (1)

Take one of the **candlelit ranger-led tours** into the cave. Be sure to check out the national park's tips for venturing underground—sturdy walking shoes are a must.

(2)

Visit the park's **prairie dog towns** (which range from one to several hundred acres in size) to see the black-tailed prairie dog up close. Small groups of prairie dogs are called coteries, and members of a coterie may greet each other with a kiss!

 3

Mount Rushmore National Memorial lies just forty miles north of Wind Cave National Park. Get up close and personal to the chiseled busts of our former presidents and visit the sculptor's studio to learn more about the artist.

This peaceful, isolated island in the middle of Michigan's Lake Superior is an adventurer's paradise. The forty-five-mile-long archipelago can be reached only by boat or seaplane, and no vehicles are allowed on the island. In the late nineteenth century, the island was populated by a small mining community. The southwest end of the island is named after the Wendigo Copper Company, which shuttered after families braved a few winters in the wilderness without striking copper. The miners' old pathways now serve as trails between campsites. The northeast end of Isle Royale is called Rock Harbor, where hikers can take a short loop to Suzy's Cave, a ten-mile hike to Mount Franklin, or paddle out to Raspberry Island.

ISLE ROYALE

NATIONAL PARK

KEWEENAW COUNTY

MICHIGAN

TOP EXPERIENCES

① Hike to **Lookout Louise**, a popular overlook on the northeast side of the island. Visitors can see across Lake Superior to Thunder Bay, Ontario, and the old mining town Sibley Cove.

② Take a leisurely paddle through the serene waters of **Washington Harbor**. Canoe or kayak along the shoreline or make your way to **Beaver Island**. Rentals are available at the Windigo Store.

③ Take a guided boat tour around the island through the **Keweenaw Waterway** or on the **Rock Harbor** side of the archipelago.

America's National Trails System was established in 1968, with the passage of the National Trails System Act. The act aimed to preserve scenic trails "for the conservation and enjoyment of the nationally significant scenic, historic, natural, or cultural qualities of the areas through which such trails may pass." Some trails allow for adventurous exploration, while others, like the Lewis and Clark National Historic Trail, offer visitors a taste of history. The Lewis and Clark National Historic Trail stretches from Pittsburgh, Pennsylvania, across sixteen states to Astoria, Oregon. The meandering path is not a hiking trail, per se, but a preserved snapshot of America's Corps of Discovery Expedition.

LEWIS AND CLARK

NATIONAL HISTORIC TRAIL

FROM PITTSBURGH, PENNSYLVANIA,

TO ASTORIA, OREGON

TOP EXPERIENCES

 1 Visit the **trail's headquarters in Omaha, Nebraska**, to learn about the history of the region as well as the famous expedition.

 2 The **Ohio River Islands National Wildlife Refuge** in Williamstown, West Virginia, explores the wildlife and historic uses of the Ohio River.

3 **Spirit Mound** in Vermillion, South Dakota, is one of the few spots along the upper Missouri River that is identified as a place Lewis and Clark visited. This spiritual place has different meanings to different tribes.

Published in the United States by Clarkson Potter/Publishers, an imprint of
Random House, a division of Penguin Random House LLC, New York.

clarksonpotter.com

CLARKSON POTTER is a trademark and POTTER with colophon
is a registered trademark of Penguin Random House LLC.

ISBN 978-0-593-23626-0

Printed in the United States of America

Editor: Sara Neville
Cover and interior designer: Annalisa Sheldahl
Design Manager: Danielle Deschenes
Production Editor: Serena Wang
Production Manager: Kelli Tokos
Marketer: Chloe Aryeh
Illustrations by Lea Carey

10 9 8 7 6 5 4 3 2

First Edition